T0023890

Arsham-isms

Daniel Arsham

Edited by Larry Warsh

PRINCETON UNIVERSITY PRESS

Princeton and Oxford

in association with

No More Rulers

Published by Princeton University Press,
41 William Street, Princeton, New Jersey 08540
In the United Kingdom: Princeton University Press,
6 Oxford Street, Woodstock, Oxfordshire OX20 1TR
press.princeton.edu
in association with
No More Rulers
nomorerulers.com
ISMs is a trademark of No More Rulers, Inc.

Library of Congress Cataloging-in-Publication Data
Names: Arsham, Daniel, 1980- author. | Warsh, Larry, editor.
Title: Arsham-isms / Daniel Arsham ; edited by Larry Warsh.
Other titles: Quotations. Selections
Description: Princeton : Princeton University Press in association with No
More Rulers, [2021] | Series: Isms | Includes bibliographical references.
Identifiers: LCCN 2020037560 | ISBN 9780691217505 (hardcover)
Subjects: LCSH: Arsham, Daniel, 1980—Quotations.
Classification: LCC N6537.A7134 A35 2021 | DDC 700.92—dc23
LC record available at https://lccn.loc.gov/2020037560
British Library Cataloging-in-Publication Data is available

This book has been composed in Joanna MT
Printed on acid-free paper. ∞
Printed in the United States of America
3 5 7 9 10 8 6 4

CONTENTS

INTRODUCTION

Throughout his career, Daniel Arsham has defied categorization. His work exists beyond the confines of art, architecture, or performance art. Despite strong ties to the visual, he is at heart a conceptual artist. He plays with the qualities of substance—making objects and materials "do what they're not supposed to do,"[1] giving walls the qualities of fabric or liquid. He also plays with time, recasting objects from the present into a state of eroded decay, as if discovered by archaeologists in the future. Through his fluency in popular culture and insights into our present moment, his work has resonated with a global generation. Through transforming the mundane,

1 Daniel Arsham, https://www.danielarsham.com/about.

he has presented us with the evidence of our material impact on the natural world, and what that narrative may look like in the future.

Arsham was raised in Miami, Florida. From an early age he was deeply influenced by the sense of illusion and fiction found in much of his surroundings, from the fantasies purveyed by Walt Disney World to Miami's very existence as a city built on swampland, its beaches lined with sand pumped in from elsewhere. At the age of twelve, Arsham's understanding of architecture was profoundly altered when Hurricane Andrew hit Florida, destroying nearly everything around him. His experience of the hurricane left a lasting impression, and images of that time have remained with him, deeply influencing his artistic practice throughout his career.

In 1999, Arsham moved to New York to attend the Cooper Union, where he excelled

in his art and architecture courses. Soon after graduating he came to the attention of the Merce Cunningham Dance Company, which invited him to tour with them as a set, lighting, and costume designer. Cunningham's unusual process of collaboration, in which each element of the performance—music, dance, and design—is developed completely independently, was a challenge for Arsham, who was only twenty-five at the time. But his success resulted in Cunningham selecting Arsham as the designer for the company's final six performances at the Park Avenue Armory in New York City.

Influenced by a trip to Easter Island, where he encountered a research expedition in progress, Arsham developed an interest in archaeology and the ancient past. He soon learned that much of what we understand about the past is created in the present and is often invented on the basis

of scant evidence. Combined with the profound impact that Hurricane Andrew had had on his psyche, this realization led him to develop the concept of "Future Relics." In Arsham's hands, familiar, everyday objects—computers, cars, gaming consoles, alarm clocks, phones—were made to appear deteriorated and eroded. Within the decay, however, Arsham inserted crystals, suggesting growth and regeneration. This concept of "Fictional Archaeology" took hold, becoming a defining thread throughout his career.

In parallel with his development as an artist, Arsham cofounded the design firm Snarkitecture with Cooper Union classmate Alex Mustonen. The firm quickly gained notoriety, combining sculpture, art, and architecture in a multidisciplinary practice. With a touch of humor, Snarkitecture projects are designed to lift participants out of the everyday and into

something unusual: a "beach" made of more than a million plastic balls, or a "house" that uses skewed perspective to explore the differences in how adults and children relate to the world around them. The firm's success led them to work with top retail brands such as Kith, Valextra, and COS (Collection of Style), among others, in designing storefronts, interiors, and installations.

Arsham's desire to reach a wide range of audiences, and his aptitude for doing so, has made him a true artist of our time. Engaging both elite members of the art world and those whom the art world frequently excludes, he transcends not only the labels of "artist" or "architect" but the realms of fine art and commercial art that such creatives usually inhabit. He manipulates the moment or place where opposite forces meet—the gray areas between construction and

destruction, illusion and reality, familiar and unfamiliar, human and inhuman. By utilizing a democratic language of materials and symbols, from Venus de Milo to Pikachu, he has broadened the scope of what it means to be an artist in the world today.

LARRY WARSH
NEW YORK CITY
JANUARY 2021

Arsham-isms

Art

Art needs to be a little dangerous. (1)

———

My work is a manipulation of something that is pre-existing, something that the audience already knows and understands in a way. It's about the breaking or the shifting or the disruption of that expectation. (2)

———

My work is never prescriptive of having a particular meaning, it is more of an invitation to travel in time or reside in an alternate space. (2)

———

A lot of the earlier paintings that I made
were things that depicted structures that
I couldn't yet construct. (47)

———

I wasn't accepted to study architecture
[at university], so I did art instead. (26)

———

As an artist, you work to create a language
to define your practice and some kind of
character or gesture that feels unique
to what you make. (7)

———

I think that the role of an artist is really to kind of evaluate culture, and evaluate people's position within the world—whether that relates to politics, fashion, ecology, film, cinema, or music and sometimes all of those things. (10)

———

I use my work personally as a way to explore what I think about the world and all of the fascinating things that occur within it. (10)

———

As an artist, if there are rules, I'm going to figure out how to break them. (16)

———

I think if it's a noir that is present in my work, it's like a future noir … like Blade Runner. (19)

———

I don't feel quite a part of the art world in a way. Or at least the New York art world. (19)

———

The art world has a tendency to feel a little bit hard to enter from the outside if you've never been or you just didn't grow up in that kind of culture. (20)

———

Pop culture is in some ways far more
egalitarian than the art world. (16)

———

Artwork takes a lot of effort and a lot of time
to create and there's a respect that needs
to be given to that. (20)

———

You don't have to own the thing to be
part of it. (20)

———

Nothing beats seeing the [art]work in real life.
(20)

———

My job as an artist is to kind of digest culture
and put back another version of it that's my
kind of version or my vision of it, or allow
people to rethink their everyday experience
and show them something that was
always there in a new way. (21)

———

[The objects] actually have nothing to do with
me in particular; they have to do with you.

(22)

———

I always go back to the painting. (22)

———

[Painting is the] only thing that I do that's only me; no one's ever helped me on a single painting. (22)

———

Even though [my work] looks like it's falling apart, parts of it are made of crystal, so it could actually be growing to a kind of completion. (26)

———

I would say first [my] drawings and then the sculptures rest in this world between construction and demolition. (27)

———

The projects are in some ways as accessible to a 15-year-old kid in the suburbs as it is to somebody who is studying architecture at Columbia. (29)

———

My work is very much about the viewer, about people's reaction to it and how they experience it. About the world that can be generated and formed around not just individual pieces but the building of a little universe of alternate possibility. (34)

———

The work is never about something specific,
it's always an invitation to think about things.
(37)

———

The art world has realized things that it knew
in the '60s when Warhol was around—that
everything about our everyday life can
be part of art. (38)

———

I think the work is quiet in a way, you might
walk into the room and not really notice it.
(44)

———

In the collaborations I've done within fashion, it's often for me about engaging an audience that is not necessarily aware of the art world, and through this channel, I am able to show them this universe. (44)

———

I'm using the brands for their reach and their ability to find an audience, which is not necessarily an art audience. The art world and museums in general can be a place that is amazing but not accessible to everyone. (46)

———

With many of my projects, I try to make work that's not just for art people. (3)

––––––

[The role of the artist is] to reinterpret our everyday lives or culture and to expose the unseen things. (46)

––––––

Certainly it's the wish of every artist to engage with people. My work is really about a conversation that's engaged through the work, and if that can be engaged across time in the future, of course that would be interesting to me. (46)

––––––

I think the role of the curator is to kind of
guide the way that the public might interpret
things, and they act as a sounding board
for understanding that. (53)

———

My work does best when it's in an audience
that is a mixture of different types of people.
(53)

———

Mixing audiences is one of my favorite things.
It's something of a cross-disciplinary and
cross-class idea. (8)

———

More people will see my exhibition from
a single post that I do on Instagram than will
actually go through a show. There's a lot
of power in that. (61)

———

[Instagram] flattens everyone out and allows a
12-year-old girl in Korea to have the same
voice as a collector in New York. (22)

———

Art definitely serves a purpose, but that
purpose is undefined and can be created
by the viewer. (53)

———

I want to make work that people can engage
with. The work is completed by people
engaging with and experiencing it. (16)

———

Artists are tasked with uncovering things
that people don't pay attention to, that they
maybe otherwise should, and provoking
responses that are outside of people's
everyday experience. I think that that can
have a huge impact on people in general,
on society, and obviously culture. (59)

———

One of the things I've tried to do with the work, and this is almost impossible[,] is to forget the meaning of some of the objects. (60)

———

[Art is] the universal translator. (61)

———

To say that art can change the world is a big statement. No single artwork can do that. It's more of a zeitgeist that you can push forward and a way of thinking that takes many artists, in many different mediums, to push forward. (61)

———

Within the art world, I think I'm thought of
more as an architect—[in the] architecture
world thought of more [as] an artist—in the
fashion world I don't know what I'm thought
of but still working on that. (10)

———

I've stayed the same, but the art world
has changed. (38)

———

I have always been creating between
fashion and art. (43)

———

I don't want to make work for a limited
audience, I want to make work that
speaks to everyone. (29)

———

My work is my life. I don't distinguish. (4)

———

Architecture

I make architecture do things that it's not
supposed to do. (17)

———

I always thought I would be an architect.
I have come back to that in some ways,
but I did that through the formation of this
practice with actual architects. I never had
the patience for the meticulous aspects
of that profession. (45)

———

I remember trying to reverse-engineer the design of the house that I grew up in, trying to make architectural drawings on graph paper of that house. It was like trying to understand that space as a 9-year-old. (45)

———

To this day I could probably draw a very accurate floor plan of the house that I grew up in, even though I haven't been there in 20 years. (59)

———

The architecture [in the Miami suburbs] was
pretty lackluster. All the houses were identical.
Your typical American suburb. As soon as I
could, I got myself out of there. (42)

The way I feel about a city has a lot to do
with how that city is designed. (42)

Architecture shouldn't be moving, right?
I think there's a kind of subtlety to that, which
creates an entry point for people to start
thinking about their reality in general.
It's a manipulation of things that they
are already familiar with. (1)

How I can manipulate architecture to make it as unsettling or uncanny as a storm? This is where I'm trying to reside, in a place that is simultaneously familiar and unsettling. (23)

———

Seeing architecture in a state of flux and movement, and in a state of decay and rebuilding after the storm, has influenced much of my practice. (16)

———

If you can imagine a storm being a violent destruction of architecture, my work has always been a sort of subtle soft dismemberment of the architecture. (33)

———

Material itself is a very important part of my work. I'm working in an architectural scale and I'm trying to create the sense that the work is made from the fabric of the architecture itself. (2)

———

My work often pushes the boundaries of building code. In the studio we like to think of this code as a material. (17)

———

Snarkitecture started as an expansion
of my own practice into a larger scale,
into public space, into architecture, and
design in some cases. (2)

———

Snarkitecture has taken on a life of its own,
and now people might not even know
I'm associated with it. (9)

———

Snarkitecture fills a personal artistic need.
There are some artists out there that can sit in
a room and work and not care whoever sees
it, but I am not that kind of artist. (16)

Within our practice at Snarkitecture, there are always ideas that float around for a while that never materialize that we'll keep on the back burner until a later date. (11)

————

Snarkitecture floats in the space between art and architecture while not really fitting into either. (17)

————

The name [Snarkitecture] is based on a Lewis Carroll poem called "The Hunting of the Snark," which is a story about a bunch of idiots searching for a beast called the Snark. All they have to go on is a blank, white map.

(59)

————

[Snarkitecture] ultimately became its own
entity with its own language. (30)

———

If an object has specific purpose it is often
relegated to Snarkitecture. If an object has
ambiguous purpose, it can often be within my
studio so we can say that it definitely serves
a purpose but that purpose is undefined,
can be created by the viewer. (10)

———

I think that it's been hard for the public,
but also for me, to define what I do. If I'm
working in architecture is it still art? (19)

———

Architecture is an additive process. (23)

———

[My Cooper Union thesis exhibition]
is one of the earliest things I created using
architecture as a medium to play with—
manipulating and creating a disconcerting,
uncanny architecture. (30)

———

When you're a child you have a different
understanding about space. You think about it
less as it was constructed and more about the
way it makes you feel or what it means. (26)

Children often use things in the wrong way: they use a knife as a spoon, they may use a handrail as a play toy. That kind of misrecognition of architecture can be helpful for creating new elements and new experiences. (59)

———

There are always similarities in terms of tone and form between my work and the work I make with Snarkitecture. The difference is that the work with Snarkitecture always has a function. (36)

———

Architecture is made to feel solid. It is made to feel permanent. This is a quality that is imperative to the experience of architecture. Whenever I can disrupt, that it is a good thing. (36)

I think [Norman Jaffe] is one of the most under-recognized architects, partially because he died very young. (38)

Architecture has rules to it. Obviously there's a reasoning behind it, but it's a bit more rigid than I'm interested in engaging with. (46)

When Ronnie [Fieg] went to go open Kith, it was kind of natural for an architect to work on the design; it was us figuring it out as we went. And we really thought about it more as an experience of not creating places for people to come and buy stuff, but creating a place for people to come and hang out. (57)

My work often manipulates architectural surfaces, and sometimes I need architects and engineers to help me work out the language. (9)

———

Architecture is the most lasting and important thing that humans can make. (17)

———

I am not an architect. (34)

———

Film and Photography

Cameras and photography were a big part
of my early art-making. (38)

My first love was black and white
photography. (13)

The first work I made was an old camera
cast in ash. (59)

Photography was something I always used as a visual note-taking device and I continue to use photography as a way to keep myself thinking and as a catalogue for travel. (29)

———

The camera is, I think, an interesting object, as it freezes time. (38)

———

Even though galleries and museums shoot work when they get it, I usually shoot my own work as well. It's a different way of looking at it. (40)

———

Photography creates a medium where the everyday can be positioned through the lens of the photographer or artist. (47)

———

There's this flow of movement where time seems fluid in the same way that the materials in my work are malleable and I'm able to manipulate them—the film uses time in that way. (37)

———

The films that are most successful in depicting the future for me contain aspects of the present. (4)

———

Film, more than anything, is the most difficult thing I have ever tried to accomplish. (4)

———

The fourth dimension is time, and film does that in a way, but it's infinitely more complex because you can watch it over and over again. You can pick things apart. (4)

———

People often think that if an artist is making a film that it's going to be some sort of art film with no story or very abstract. There are elements of *Future Relic* that are like that, but there is a story that is closer to a Hollywood style thing. (4)

———

When I'm on set, I'm just devoted one
hundred percent to that. (31)

———

When I presented my film at Cannes and
Tribeca, people thought it was visual art,
so it's an interesting place to be: on the
periphery of all these things. (37)

———

[Steven Spielberg and Robert Zemeckis] had
an influence on my childhood and particularly
thinking about image making through
photography and film. (1)

———

The next sort of large gesture for me,
I think, is in film. (39)

———

I started [the Future Relic series] because
I noticed that, when people wrote about these
fictional objects, they often invented a
scenario around them. I thought that I could
control and direct that narrative—even make
my own story about the future
with these objects. (39)

———

Having the films made in short bursts is easier
than dedicating months to work on it. (4)

———

A kind of favorite topic of conversation with people is, "What's your favorite cinema car?" (57)

———

Much of my work has been about this sort of confusion of time or bringing things from the past and making them appear as if they're in the future; and the film [*Hourglass*] definitely plays with that idea and sort of integrates the piece that we made together into a kind of narrative. The film really is about my work and about my life in many ways. It sort of crosses between documentary and narrative in a really sort of unique way. (58)

———

Film is something that I've always been
interested in. It is, for me, the kind of
complete universe that encapsulates all the
other areas in which I work: architecture,
scenography, photography. All the props in the
film are things that I've actually made, and it
allows me to bring all those together
into one sort of universe. (59)

———

In the gallery, I can control certain things,
the temperature, the smell, but I can't control
how people experience things in such a
direct way as I can with a film. (37)

———

Film is an area that for me is the most holistic.
Every single thing is considered. (37)

———

Process

I don't have any preference in terms
of my disciplines. I love working in many
different areas. (10)

In the studio, I can be whatever I say I am. (6)

I'm [at the studio] every day at 9 o'clock. (29)

I always want to dream up things that
go beyond what people have
experienced before. (24)

I'm most content when I'm working on the next big thing. (16)

———

The studio is set up more as a laboratory for experimentation. (49)

———

I'm using something that already exists. It's a transformation of that thing rather than a reinvention of it. (12)

———

When I do sculpture, I always make drawings beforehand. (3)

———

All of the molds are handmade ... In order to do that, you have to be able to pull the object apart in your mind. It's like reverse engineering. I had to start with very simple forms to get to that place. (4)

———

There's a lot of failure in what I do. I try stuff. It doesn't work. I just keep going. (4)

———

The reason I feature iconic characters in my work is that they are very recognizable and, on the surface, they make it easy to enter my work. Once you're inside, things get more complicated, but it's easy to enter. (3)

Oftentimes when I'm looking for gestures to use, I'm trying to locate gestures that have broad historical relevance, something that we might see in contemporary life, or might be related to religion. (5)

———

It's helpful to make work from a particular vantage point. (6)

———

Sometimes you do have to repeat yourself many times to get an idea across. (20)

———

I could have taken a camera and painted
it to look old, but something about this kind
of alchemy—this shift of material—gives a
greater weight to the objects, and gives a kind
of truth to them that is more powerful. (7)

———

I despise titling exhibitions, and artwork
for that matter, so we've come up with a
system in the studio where words are selected
somewhat at random from things that I've
said in interviews or in books in the past and
they are combined through chance. (10)

———

The reason the black works are black is
because the volcanic ash is black and the
crystal is white. So there's a kind of
truth to the materials. (12)

———

I never try to be prescriptive about what I'm
trying to portray. I want to create a universe
that all of these works can exist in. (13)

———

I'm trying to investigate our current moment
in time and the big ideas within our
civilization. I'll do that through as
many mediums as I can. (16)

———

I enjoy what I'm doing too much to
take a break. (16)

———

I bring a lot of objects and materials
into the studio and I often sit for hours
looking at these objects. … [these objects]
begin to tell me what they want within
their own logic. (17)

———

My approach is to make things that I need
and want that don't already exist. It's a bit
like alchemy. (18)

———

It's the making that's the obsession for me. (18)

———

eBay is like this contemporary Library
of Alexandria. (22)

———

Maybe I'll continue in white, but it may
be like a rainbow world in ten years. I have
no idea. I think it's really about paying
attention to materials. (19)

———

I need the audience in order to complete
the work. (21)

———

When I am looking for a Polaroid camera to
cast I'm going to be looking for *the* Polaroid
camera that we all remember. (22)

———

I get into these eBay black holes for six hours.
I'll wake up in the morning and I'll have
bought a huge McDonald's sign. (23)

When we pull the pieces from their molds,
it's like Christmas! (23)

———

I have always been interested in the ideas
around the stage, as it presents a unique
opportunity to view sculpture, as you have
a fixed viewpoint. In a gallery, people
walk around your sculpture; whereas,
from a fixed point there is so
much illusion possible. (27)

———

Within the studio, I'm usually wearing white
or [a] light color ... a lot of the material
we work with is light and color so [it]
keeps me clean. (28)

———

I always worked with what I had, while
pushing the ability both of myself and the
people I was collaborating with to make the
biggest, most difficult thing possible. (29)

———

Many of the concepts that are present in my
work today were things that were developed
on a plane five years ago. (29)

———

Each time I get to a place, I'm pushing—
where can I take this next? (29)

———

A lot of my work is about taking things
that people already know and that they have
an expectation about, and subtly
transforming that. (29)

———

I don't ever try to make things have a
specific meaning. I try to allow things to
have many potential meanings. (29)

———

I'm always taking notes about things. (29)

It's about pacing yourself. There's only a
limited amount of work that I can produce
in any given year, so I'm not doing
30 shows in a year. (29)

When I feel strongly about something, I make
a very serious stand for it. (29)

Most of the museum exhibitions that I'm working on are years away. (29)

———

In my work, materials are always as important to the concept as the visuals they create. (30)

———

In a museum or gallery, I usually have carte blanche but my gestures are temporary. Public space requires a different knowledge base. (30)

———

[My studio space] is often chaotic and a place of experimentation and mess. (30)

———

I have my studio, the architecture practice, Snarkitecture, and then a film company. Each one is separate, but there is some crossover of ideas. Like Snarkitecture may work on some set design for a film project or my studio may loan production methodologies to the architecture practice. (31)

———

When I first started casting these pieces I didn't quite know how to get the materials to adhere together properly and some of the early ones would slowly melt or would fall apart. (31)

———

When I'm selecting these actual objects,
I am spending a great deal of time finding
an object that is an icon in itself. (33)

———

I want [the sculptures] to appear that they are
falling apart, but I don't want them to fall
apart. I want to keep them in a frozen stasis.
(33)

———

Let's say a camera gets calcified over a
thousand years in crystal. It would look just
like the one I made, and the materiality
will be the same. (6)

———

When I started thinking about doing a large-scale object, a car came to mind. I began to think about my favorite cinema cars. And obviously the DeLorean is a specific one. But the DeLorean itself has its own kind of interesting history, because it was this kind of failed projection of the future, and yet 30 years later it still is kind of very futuristic looking and elegant in a strange way. (57)

———

In *Ferris Bueller's Day Off*, the cars that you see [moving] on screen are not actually real cars. They're all replicas that were built by a prop master. The only real GT was shown parked in the garage of this kind of Mies van der Rohe–like modernist style Chicago house where the father who owns the car lives. I bought the DeLorean, but for the Ferrari I found the guy who made the prop cars for *Ferris Bueller*. He made this prop car for me based on the original he made. (57)

―――

This work for me is not about progress. It is about destruction and growth and where they are able to meet in the middle. (36)

―――

The material, in some ways, tells you as much about the idea as what the object looks like.
(38)

———

Even though my work has a small impact in terms of carbon footprint, we purchase carbon offsets for all my travel. (38)

———

When I'm looking at materials, I'm selecting them for properties other than color. (39)

———

I select the color inadvertently through the
selection of the material. (39)

———

Everything that I make uses something that
people already know, that they already have
a reference for, and disrupts it. (39)

———

I certainly use performance in my work,
although I wouldn't call it performance art.
(39)

———

I work in many different mediums because I find opportunities in them to expand how I convey the ideas in my work. (39)

———

I like to do things in a specific way to make sure they're done correctly, and I'm not willing to sacrifice that for anything. (45)

———

I studied casting in school, with plaster, resin, and things that are quite natural, but casting something in a material like ash that needs to be coaxed into forming, a lot of it is a kind of material science. (46)

———

You don't learn how to cast ash in art school. (33)

In some ways the selection of material is as important as the visual quality of degradation. (46)

Much of the time when I'm making my sculptural work, I'm inventing a personality, or persona, to embody. (48)

Confusion/uncertainty is really where
the work lies. (2)

———

I just want to exist in a world that is easy.
And, when I say easy I mean that there aren't
people yelling and there's no stress. There's
issues and things that happen but you just
deal with them as they come. (4)

———

It's very easy to dwell and spend time
ruminating over something, but there's
nothing to be done about it. It's better
and more efficient to move. (4)

———

There are no shortcuts. Following your passion means doing the hard work and seeing your art through to its inevitable conclusion. (16)

———

I always look for multiple entrance points so viewers can recognize them. (30)

———

Failure can be [important] as both a motivating factor to not repeat but also to understand how and why many things don't work. It can be a tool. (30)

———

Questioning one's surroundings is one of
the main things you have to do both as
an artist and a person. (34)

———

I will always stay optimistic. (37)

———

I would love to say I would continue to make
work if there were no viewer, if I was the last
person here, but I don't think I would. (34)

———

It's rare that I use digital processes in
my work. (51)

———

I've used technology in the service of
my work when it suits, but very seldom have
I used it in the actual production
of artwork. (52)

———

I've been doing a lot of things in industries that are different from my own, so a lot of stuff recently in fashion, clothing design, and wearable items. And I think they bring the kind of aura and the regimented practice from the studio into a wider range, and kind of built an ethos around how the studio is set up. (53)

―――――

I don't really have any preference in terms of my disciplines. I love working in many different areas. (53)

―――――

I picked a number of the different Pokémon that I wanted to create works out of, and the company was able to send us three-dimensional files. Oftentimes, these are used as graphics … so they're presented in a two-dimensional way. And obviously, we need to translate these into sculptural objects, so there was a lot of sculpting. What we did is we 3-D printed their original files, and then we sculpted with clay on top of those. We made molds of that, and then cast the final works from that. So it was a bit of a multiple stage process. (55)

———

There are very few materials that I wouldn't have some sort of idea to manipulate. (59)

———

Since I've started making work, it always feels like whatever idea I'm delving into in the present is the last good idea. (61)

———

Once I have made a work and I have spent enough time with it in the studio, it is done for me. My interest is in the process. (34)

———

Influences

I grew up with Pokémon and collected the cards when I was a kid. (50)

———

[My grandfather] had a big influence on my thinking around the appreciation of objects.
(47)

———

I grew up among a kind of tropical forest landscape. I spent a lot of time out in the Everglades and out on the water, so the Miami that everyone imagines now with partying and South Beach—that was not at all part of my childhood. (59)

———

I remember realizing for the first time that the architecture's all fake [at Walt Disney World] and not only is it fake but it's all an illusion. For instance, in places like Epcot Center, the buildings that look really tall ... it's all forced perspective ... on the first floor the windows are 100% sized, on the second floor they shrink to 80%. So if you see a bird land on the top window, the bird's going to look huge. All of that illusion stuff is what I love about that place. Illusion is something that I use a lot in my work. (22)

———

Cooper Union was this dream place to go to.
I had been to New York City once in my life.
(29)

———

Sometimes I fantasize about living somewhere
else, but to be honest, I'm not sure that I
could live anywhere except New York. (42)

———

[Working with Merce Cunningham] was
amazing and sort of terrifying at the
same time. (31)

———

When I was asked to make that first stage design, Merce was telling me, "I want you to do this," and him saying that he believed I could do it. He gave me the confidence to pursue that. (4)

———

Since I was younger, and even in art school, I wasn't necessarily hanging out with the art kids. I always gravitated more towards people in fashion, architecture[,] and music. Seeing how these people in other industries build a language or style is informative for me in my own work. (35)

I'm color blind. It doesn't mean that I don't see color, but the range that I see is drastically reduced from what you would see. (31)

———

I knew that I was color blind all my life. It's not something that was pointed out to me on many occasions or something that I even thought about as being part of my work. (29)

———

I got these lenses that correct my color blindness ... and it's crazy. Before I could see like twenty percent and now I can see eighty percent. (31)

———

My color blindness for me has always
been something that has receded into the
background but more recently, I began to
explore it as a means of the selection of
materials within my work. ... I want to be
able to look at something and know that what
I'm seeing is what others are seeing as well
so that I can properly execute whatever
it is I'm trying to do. (10)

I really like science fiction, and it's certainly
influenced my film work. (7)

Travel is certainly something that inspires me; it keeps me thinking about the world around me. (10)

———

I look at a lot of young artists from designers like Sabine Marcelis, to people working in fashion like Samuel Ross, to more traditional painters like Reginald Sylvester or Alex Gardner. (10)

———

Most of the people I surround myself with
are not visual artists; they're musicians
or in fashion. (1)

———

I'm friends with a lot of people who didn't
study anything related to fashion and now,
that's all they do. Or they started in fashion
and are now working in art. That's our
generation—things are just
much more fluid. (37)

———

A lot of these people that I am able to work
with are seriously geniuses. (22)

———

For people of my generation, and friends
of mine, streetwear is just the stuff that
we grew up with. (20)

———

Part of the fascinating thing about other
artists, designers, filmmakers, or other people
is seeing what they're looking at outside
of their own work. (37)

———

My wife is Japanese, so I'm partially
influenced by her as well. (38)

The [Japanese] gardens are something that
appear permanent[,] that are always the same
every time you go yet are remade each time,
remade each day[,] and something about that
idea of permanence and ephemerality has
always been interesting to me. (28)

The impact of the architecture [in Japan] and
the landscape had a profound effect on my
work and thinking after that. (50)

Even though I guess I always knew that [Pokémon] was a Japanese cartoon, it felt like something that touched everywhere in the globe. … Even if they're Japanese people, people in China, people in the US and in South America, they all kind of know these characters and understand them and in a certain kind of way. (55)

———

I travel a lot and that's had a big influence on my work. (37)

———

Culture is what we define ourselves by. (25)

———

Being a person who is engaged with culture ... can be part of your identity. (20)

———

I've always *liked* sneakers but I wouldn't have
called myself a "sneaker-head" before
I met Ronnie [Fieg]. (37)

———

I think 10 years ago [when discussing]
the origin of the work, the state of the ecology
of the planet and the environment was less
of a topic, so the works were more related
to a sci-fi post-apocalyptic universe.
Now … there's a conversation around
the environment and what's happening.
It's a huge concern for me. (38)

———

From the beginning of my career, I worked with a number of different people in different disciplines. It was a choice to collaborate, to try to understand other people's way of working, and most of the people that I've surrounded myself with, even up to today, don't work in the discipline that I work in; they work in fashion, or music, or architecture. (53)

I have a two-and-a-half-year-old son named Casper. He's very immediate. I think that his influence on me is as kind of a different way of looking at things. I've often incorporated, even before his birth, ideas that were related to how a child might interpret the world. I try to cause scenarios where people misrecognize architecture; where scenarios that might otherwise be very rigid and fixed can become malleable and fluid. (59)

———

Being a dad has brought me back to my own childhood, where everything holds wonder and is new and fresh. One of the greatest joys of being a parent is seeing things the way your children do, through completely fresh eyes. (41)

I try and do a regular pilgrimage to Disney World. (2)

I always thought of Walt Disney as kind of the penultimate artists creating complete universes for different characters. (51)

I see Mickey in many ways as the origin of Walt Disney as an artist, as a pretty simple idea from his first cartoons to this vast universe of inspiration to so many people in the world.

(51)

———

I was always fascinated with the idea that everything in the Disney universe came from the mind of one person. (51)

———

Miami still has an influence on my thinking.

(22)

———

Where you come from always has something
to do with what you continue doing in life.
(22)

My work has certainly changed my life.
I hope that it has done the same
for others. (34)

Past, Present, and Future

Time doesn't have a shape. (14)

———

Archaeology has always been the method
by which we understand ourselves, where
we've been, what we accomplished, what are
our failures. As a society, they marked different
periods in history. And oftentimes, especially
for more ancient civilizations, the things
that we have to understand those
civilizations are artworks. (56)

———

Archaeology inherently is fiction, and there is
no definite way of telling those stories because
we didn't exist in that moment. (47)

———

The whole series of archaeological pieces began after a visit to Easter Island a couple of years ago. ... Archaeologists were re-excavating Moai that had previously been excavated about a hundred years ago. They found objects that had been left by earlier archaeologists in conjunction with the Moai statues. It occurred to me that this confusion of time offered an interesting place for work to reside. (39)

As history progresses, all objects become antiquated and in some way, they all become ruins or relics, disused or buried. In 1,000 years everything that we own will inevitably become one of those things. I don't particularly see that as having an apocalyptic quality—it's sort of just the march of time and moving on. (1)

I've had a long-standing interest in small-scale depictions of the figure across time from antiquities to the future. (38)

Most of the objects I'm using are things
that don't exist in our everyday, they are things
that are just slightly past, yet they already feel
like they are from the past. That bridge in time
is important in order to imagine these
things as relics. (5)

———

There's a kind of inevitability that I see, that
all of the things that are present in our life
will someday become a ruin. But it doesn't
mean that that's a kind of negative, right?
It's just part of the continuation of
things moving forward. (57)

———

Even after developing all of the stories and the basis for Egyptology, for a long time they still didn't realize that a lot of stuff was painted. So my position is that we think that we can know the past, but in fact we know the past as well as we know the future. (59)

I found it productive to dislocate myself from a particular moment and be able to freely associate with different eras. (46)

My memories don't feel like memories—they feel like predictions. (14)

When I want to remember the time period of my childhood and teenage years, I think of what kind of sneakers had just come out, or what activities me and my friends were doing at that particular moment. The things we experienced, or the objects we held create this essential tactile dimension to the remembrance of time. (15)

I often think about how we define a particular moment in time, and it's always through some tangible element or a lived experience, rather than the months of the year or the time on the clock. (15)

———

The in-between state of growth and decay through time is something I've explored a lot. (15)

———

This specific idea of the confusion of time has been present throughout the work. (7)

———

The present is like a knife's edge. It doesn't
really exist, it's so fleeting. (14)

———

The hourglass ... defines time, it gives it
a tactile dimension. (15)

———

I spend a lot of time thinking of ways
in which I can dislocate people from
the particular moment in time
they're existing in. (15)

———

I'm fascinated with the idea of a collapse of time. (26)

I like the idea of building this metaphorical bridge, thinking about something from the past and bringing it into the future. (15)

The further you get from a moment in time, the more closely things connect. (16)

There is a moment when the building being constructed is halfway up and the building being demolished is halfway down and they meet in the middle. They are in this bizarre place where you really can't distinguish between them. This moment had a big impact on the work I create. (27)

———

Time travel and a fluid idea of time is something that I use heavily. (37)

———

I always loved science fiction and movies that dealt with time travel. I think escaping a particular moment, being able to see something that hasn't yet happened, or even travel back in time and experience an era before was always fascinating to me. (38)

In my early paintings, I created scenarios that didn't include people in them, which allowed them to float in time; they could be in the future or the past. I felt people would lock the images in a particular time because of how they were dressed or how their hair was cut.

(38)

The same way that I enjoy playing
with people's notion of architecture, their
expectations about it, I do the same, or
I attempt to do the same, with time, to try
to dislocate people in time. (54)

———

My general feeling about time, and the
present, the past, and the future is as malleable
as the other materials in which I work. (59)

———

I'm really trying to find materials that allow
me to put a real sense of time [into my work],
rather than trample that effect. (5)

I've always liked a feeling in my work that it can float in time. (61)

———

You look at something from the present and it appears as if it's a thousand years old, and suddenly you've been transported to a future place where the object could appear this way. (39)

———

I think 10 years from now would feel almost exactly like today but further into the future would probably feel considerably different. (1)

———

When we go to the future, we see the luminance of this time illustrated through icons of global culture. (3)

Part of what I love about depictions of the future are when they feel very real and pedestrian. I try to combine elements of the present to allow viewers to feel like it's not so removed from their everyday life. (59)

The future I'm interested in is pedestrian and everyday. (32)

[One hundred] years from now, I think
for any artist the best we can hope for is to
influence and speak to the current moment in
time given the social, political, geographical
climate, and all the issues that we deal with
in our present-day scenario and how
people approach the work. (28)

———

The future is a projection of what we think is
lacking in our own time mixed with our
hopes and fears about progress. (36)

———

I am fascinated with the future because of its ability to encapsulate so many different ideas. (36)

———

Each moment in which you arrive is the future. You've already arrived at it. (59)

———

The present and the past can only be what they are, the future is open. (36)

———

I'm taking the past and jumping over the present into the future. (23)

———

SOURCES

1. "Daniel Arsham: The Time Traveller." *52 Insights*, March 1, 2018. https://www.52-insights.com/daniel-arsham-time-traveller-art-interview/.

2. Licata, Joseph. "Inner-View: Daniel Arsham on Inspiration, the Challenge of Time, and His Love of Disney." *Surf Collective*, July 9, 2014. https://www.surfcollectivenyc.com/inner-view-daniel-arsham/.

3. "Interview with Contemporary Artist Daniel Arsham." *UT2020magazine*, April 22, 2020. https://www.uniqlo.com/jp/en/contents/feature/ut-magazine/s23/.

4. Morales, Eric. "The Future Relic: An Interview of Artist and Fictional Archaeologist Daniel Arsham." Interview. *Autre*, September 11, 2015. https://autre.love/interviewsmain/2015/9/11/the-future-relic-an-interview-of-daniel-arsham.

5. Callahan, Sophia. "Meet Daniel Arsham, an Archaeologist from the Future." *Vice*, April 9, 2015. https://www.vice.com/en_us/article/bmyvew/meet-daniel-arsham-an-archaeologist-from-the-future.

6. Simonini, Ross. "Daniel Arsham." *Interview Magazine*, April 7, 2014. https://www.interviewmagazine.com/art/daniel-arsham-1.

7. Lockner, Logan. "Q&A with Daniel Arsham at the High." *Burnaway*, March 6, 2017. https://burnaway.org /interview/daniel-arsham-interview/.

8. Park, Gunner. "Daniel Arsham Became One of Today's Most Important Artists by Showing Our Destroyed Future." *Highsnobiety*, October 17, 2019.

9. Gassmann, Gay. "Inside Artist Daniel Arsham's Long Island Escape." *Architectural Digest*, November 10, 2019. https://www.architecturaldigest.com/story/inside-artist -daniel-arshams-long-island-escape.

10. "Daniel Arsham: Dislocating People in Time." *Mendo*, January 2019. https://www.mendo.nl/journal/stories /interview-daniel-arsham/.

11. Tommasiello, Mike. "Interview: Daniel Arsham on His Ethereal Coachella Installation." *Cool Hunting*, April 18, 2018. https://coolhunting.com/design/daniel-arsham -coachella-2018/.

12. "Ashes to Ashes: Interview with Daniel Arsham." *Post-ism*, October 8, 2015. https://post-ism.com/2015/10/08 /ashes-to-ashes-interview-with-daniel-arsham/.

13. Chang, Jessica. "Interview: Daniel Arsham." *Tatler Hong Kong*, January 17, 2014. https://hk.asiatatler.com/life/interview -daniel-arsham.

14. Arsham, Daniel, and Ben Nicholas. *Hourglass: Past (Part 1)*. Magna Carta. Commissioned by Adida's Originals. https://vimeo.com/225509888.

15. Baconsky, Irina. "Daniel Arsham on the Science and Technology that Inspires His Work." *Dazed Digital*, October 12, 2018. https://www.dazeddigital.com/art-photography/article/41794/1/daniel-arsham-hourglass-armillaries-science-art-adidas-originals-film-shoe.

16. McClellan, Michael D. "Daniel Arsham: Ground Breaker." *15 Minutes With*. https://www.fifteenminuteswith.com/2019/02/10/daniel-arsham-ground-breaker/.

17. Churchill, Maude. "A Conversation with Snarkitecture Practitioner and Artist Daniel Arsham." *Highsnobiety*, March 4, 2013. https://www.highsnobiety.com/p/a-conversation-with-artist-daniel-arsham/.

18. Christensen, Mike. "Artist Daniel Arsham on Working with Kim Jones Ahead of His International Exhibition." *GQ*, January 22, 2020. https://www.gq.com.au/style/news/artist-daniel-arsham-on-working-with-kim-jones-ahead-of-his-international-exhibition/news-story/4cceea50f036d4cde44ab3043df983f6.

19. "Daniel Arsham, Colorblind Artist: In Full Color." *Semaine*. https://www.semaine.com/stories/daniel-arsham.

20. "Daniel Arsham on Popular Culture Influence." *Hypebeast*. https://strategyand.hypebeast.com/streetwear-report-daniel-arsham-popular-culture.

21. Chang, David Kenji. "Daniel Arsham—The Time Traveler." *Maekan*, January 5, 2017. https://maekan.com/article/daniel-arsham-the-time-traveler/#.

22. Cunningham Cameron, Alexandra. "Daniel Arsham." *Miami Rail*. https://miamirail.org/winter-2014/daniel-arsham/.

23. Beaumont-Thomas, Ben. "Daniel Arsham: The Casio Archaeologist." *Guardian*, December 5, 2013. https://www.theguardian.com/artanddesign/2013/dec/05/daniel-arsham-casio-archaeologist-artist-pharrell.

24. Yeung, Gavin. "Ronnie Fieg & Daniel Arsham of Snarkitecture on the Power of Creative Partnership." *Hypebeast*, September 23, 2015. https://hypebeast.com/2015/9/ronnie-fieg-daniel-arsham-snarkitecture-kith-brooklyn-revamp-interview.

25. "What Does Culture Mean to Daniel Arsham?" *UT2020magazine*, February 27, 2020. https://www.uniqlo.com/jp/en/contents/feature/ut-magazine/s7/.

26. Taylor, Joanna. "Get to Know Futuristic Designer Daniel Arsham." *Evening Standard*, October 16, 2019. https://www.standard.co.uk/lifestyle/esmagazine/designer-daniel-arsham-interview-a4262016.html.

27. Breukel, Claire. "Repeated Wants, Building Blocks and Backdrops: An Interview with Daniel Arsham." *Artpulse*. http://artpulsemagazine.com/repeated-wants-building-blocks-and-backdrops-an-interview-with-daniel-arsham.

28. Glamcult. "In Conversation with Daniel Arsham." Q&A, https://www.glamcult.com/articles/in-conversation-with-daniel-arsham/.

29. "How Daniel Arsham's Experimental Art Attracted Collabs with Pharrell and Adidas." *Complex*, August 7, 2017. https://www.youtube.com/watch?v=XSI_DP1FWFc.

30. Waddoups, Ryan. "10 Questions with ... Daniel Arsham." *Interior Design*, September 4, 2018. https://www.interiordesign.net/articles/15376-10-questions-with-daniel-arsham/.

31. Silveria, Paige. "An Exclusive Interview with Daniel Arsham at His Studio, New York." *Purple Diary*, July 1, 2016. https://purple.fr/diary/an-exclusive-interview-with-daniel-arsham-at-his-studio-new-york/.

32. Chaplin, Julia. "Why Celebrities Are So into Artist Daniel Arsham." *New York Times*, January 21, 2015. https://www.nytimes.com/2015/01/22/style/why-celebrities-are-so-into-the-artist-daniel-arsham.html.

33. Morrissey, Siobhan. "Artist Daniel Arsham Does 'Archaeo-logical Dig' at Locust Projects." *Miami Herald*, November 11, 2014. https://www.miamiherald.com/entertainment/visual-arts/article3773207.html.

34. "Daniel Arsham." *Not Not Awesome*, issue 2, August 20, 2013, 32–37 https://issuu.com/notnotawesome/docs/nna_issue2_final.

35. Ingvaldsen, Torsten. "Streetsnaps: Daniel Arsham." *Hypebeast*, December 6, 2019. https://hypebeast.com/2019/12/daniel-arsham-streetsnaps-style-interview-the-hour-glass.

36. Callahan, Sophia. "We Talked to the Archaeologist from the Future About His New Show." *Vice*, March 20, 2016. https://www.vice.com/en_us/article/aenq5z/daniel-arsham-future-was-then-scad-interview.

37. Kane, Ashleigh. "Daniel Arsham Travels through Time in Latest Film." *Dazed Digital*, July 13, 2017. https://www.dazeddigital.com/artsandculture/article/36660/1/daniel-arsham-travels-through-time-in-latest-film-adidas-originals.

38. "Back to the Future with Daniel Arsham." *#legend*, February 4, 2020. https://hashtaglegend.com/magazine/back-to-the-future-with-daniel-arsham/.

39. Carpenter, Kim. "Playing with Perception: A Conversation with Daniel Arsham." *Sculpture Magazine*, December 1, 2014.

https://sculpturemagazine.art/playing-with-perception
-a-conversation-with-daniel-arsham/.

40. Gayduk, Jane. "Studio Visit with Dystopian Artist Daniel
 Arsham." *L'Officiel Art*, September 11, 2018. https://www
 .lofficielusa.com/art/daniel-arsham-galerie-perrotin-2018.

41. "Being Dad: Daniel Arsham." *The Tot*. https://www.thetot
 .com/mama/being-dad-daniel-arsham/.

42. "Daniel Arsham and New York." *LifeWear Magazine*. https://
 www.uniqlo.com/jp/ja/contents/lifewear-magazine/us
 /daniel-arsham/.

43. Estiler, Keith. "A Look inside NANZUKA's '2G' Studio in
 Tokyo." *Hypebeast*, December 17, 2019. https://hypebeast
 .com/2019/12/nanzuka-2g-sorayama-hajime-daniel
 -arsham-interview-hb-japan-exclusive.

44. Brohman, Amanda. "Artist Daniel Arsham on His Fluid
 Perception of Time, Art, and Fashion." *CR Fashion Book*,
 September 10, 2018. https://www.crfashionbook.com
 /culture/a23065836/artist-daniel-arsham-on-his-fluid
 -perception-of-time-art-and-fashion/.

45. Ferro, Shaunacy. "Why Designer Daniel Arsham Won't
 Work for Anyone but Himself." *Fast Company*, March 20,
 2015. https://www.fastcompany.com/3044031/
 why-designer-daniel-arsham-wont-work-for-anyone
 -but himself.

46. "Time Travel: Daniel Arsham." *Portfolio Magazine*, issue 38, April 2020.

47. "A Life Less Ordinary: Daniel Arsham." *Artforum*. https://www.artforum.com/video/from-sotheby-s-daniel-arsham-79838.

48. "Interview: Daniel Arsham." *Tatler Hong Kong*, January 15, 2014. https://www.youtube.com/watch?v=W62HNVKeEVo.

49. "Daniel Arsham x ANICORN Watch." *Anicorn Watches*, May 7, 2018. https://www.youtube.com/watch?v=U-Gq9Su95yw.

50. "Bijutsu Techo Interview: Japanese Gardens." Otter.ai, audio file, June 4, 2020.

51. "Mickey: The True Original Exhibition." New York City, Otter.ai, audio file, October 18, 2018.

52. "Hypebeast: FUTURECRAFT 4D Collab." Otter.ai, audio file, October 15, 2018.

53. "SOLUNA_Quancard Contemporary." Otter.ai, audio file, October 29, 2018.

54. "MENDO Journal_Rizzoli Book December 2018." Otter.ai, audio file, December 11, 2018.

55. "Hills Life Magazine: Pokémon." Otter.ai, audio file, January 23, 2020.

56. "Modern Weekly China_Dior Homme." Otter.ai, audio file, April 8, 2020.

57. Solway, Diane. "How Artist Daniel Arsham Brought His Iconic Movie Cars Back to the Future in His Solo Exhibition." *W Magazine*, September 8, 2018. https://www.wmagazine.com/story/daniel-arsham-artist-exhibition-perrotin-cars/.

58. Rubin, John. "Interview: Daniel Arsham on His Multi-Faceted Collaboration with Adidas Originals." *Coolhunting*. https://coolhunting.com/culture/daniel-arsham-new-york-adidas-originals-hourglass/.

59. Wallin, Yasha. "Daniel Arsham: How the Miami-born Artist Is Becoming the Archaeologist of the Future." *Edition*, issue 3. https://theeditionbroadsheet.com/article/daniel-arsham/.

60. Alexander, Andrew. "A Conversation with Artist Daniel Arsham about His Crystalline Reflections on Time." *Artsatl*, March 7, 2017. https://www.artsatl.org/conversation-artist-daniel-arsham-crystalline-reflections-time/.

61. "Daniel Arsham—How to Twist People's Expectations with Art." Podcast. *Nion*, April 13, 2016. https://nionlife.com/daniel-arsham/.

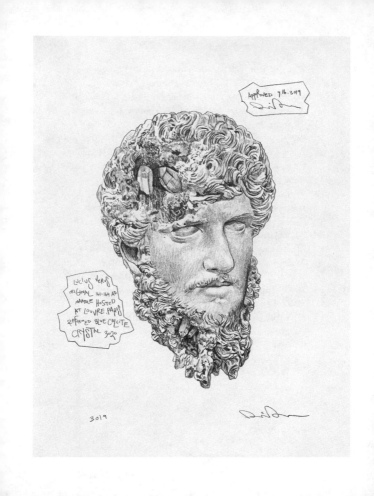

APPROVED 9.16.3019

LUCIUS VERUS
ORIGINAL 161-169 AD
MARBLE HOSTED
AT LOUVRE PARIS
REFORMED BLUE CALCITE
CRYSTAL 3020

3019

CHRONOLOGY

1980

September 8: Daniel Lambert Arsham is born in Cleveland, Ohio.

1983

Arsham's family moves to Miami.

1985

Arsham's parents bring him to view *Back to the Future* in theaters. The film has a lifelong impression on the artist.

1991

Arsham's fourth-grade report card shows he has promise in the arts.

On his eleventh birthday, Arsham is given his first Pentax K1000 camera as a gift from his grandfather, and he begins proficiently taking photos.

1992

Arsham is diagnosed with severe red-green colorblindness, a condition that is relevant to his artistic practice throughout his life.

Hurricane Andrew strikes Miami, Florida. Arsham's home is
destroyed with him and his family inside. They are nearly
killed as a result.

1993

Arsham's fifth-grade teacher writes a note of encouragement
for him to continue working in the arts and offers to
develop three rolls of his film per week.

1994

Arsham takes photos during a family trip to the Grand
Canyon and is inspired by the dramatic natural landscape
in contrast to that of his home in Miami.

Arsham attends Design and Architecture Senior High School
(DASH) in Miami. His high school studies are focused on
architecture.

1999

Arsham is the recipient of the prestigious YoungArts award in
Visual Arts.

Arsham is admitted to the Cooper Union in New York City.

2001

At the age of 20 Arsham is included in the exhibition *The
House at MOCA* at the Museum of Contemporary Art in

Miami, Florida, curated by Museum Director Bonnie Clearwater, exposing the young artist's work to an expanding art scene in the city at that time.

2003
Arsham graduates from the Cooper Union with a bachelor of arts degree and is the recipient of the Jacques and Natasha Gelman Trust Fellowship.

Arsham returns to Miami to participate full-time at the artists collective "The House," of which he was a founder. During this time Arsham begins working on his first iterations of the *Architectural Anomalies* series.

French gallerist Emmanuel Perrotin visits The House in Miama, where he meets Arsham and sees his work for the first time.

2004
Arsham participates in the group show *Miami Nice* at Galerie Perrotin, Paris, where he shows painting and sculpture in which natural and architectural worlds combine.

Arsham's work is included in the group exhibition *In Situ*, at the Museum of Contemporary Art, Miami, Florida.

2005
Emmanuel Perrotin begins officially representing Arsham and

gives him his first solo exhibition, *Homesick*, at the Galerie Perrotin, Paris, France.

Arsham is included in the seminal exhibition *Greater New York* at MOMA PS1 showing works from the *Architectural Anomalies* series.

Fashion designer Hedi Slimane commissions Arsham to design the fitting rooms for Dior Homme's Los Angeles shop.

Arsham is introduced to legendary American dancer and choreographer Merce Cunningham and begins occupying the position of artistic advisor and stage designer previously held by artists such as Robert Rauschenberg and Jasper Johns.

2006

Merce Cunningham asks Arsham to design the set for his piece *eyeSpace*, which featured the facade of a theater building that seemingly dissolved into the surface of the stage and reemerged from the ceiling.

2007

Driven by the intention to produce larger scale projects, the architecture firm Snarkitecture is founded by Arsham and fellow Cooper Union classmate Alex Mustonen.

Arsham curates the multidisciplinary exhibition *Guild* at the
Galerie Emmanuel Perrotin in Miami, which combined
art, craft, architecture, and functional objects. The exhibi-
tion is an early example of Arsham's ongoing collabora-
tive, multidisciplinary practice and interest in design.

Arsham's solo show, *Playground*, at Galerie Perrotin in Paris,
further expands on concepts of Architectural Intervention
with figures that appear to be trapped or wrapped within
the walls of the gallery.

Arsham begins collaboratively designing sets with choreo-
grapher Jonah Bokaer.

Institute of Contemporary Art, Miami, acquires
Ode/Eon Marquee.

2009

The stage design from REPLICA is created, in which dance,
performance, and sculpture intersect in a performance
excavation of a cube of matter onstage. The performance
tours globally to locations such as the New Museum in
New York, Festival d'Avignon in France, and IVAM
Frontiers of Time in Valencia, Spain.

2010

Arsham travels to Easter Island to complete a series of paint-
ings commissioned by Louis Vuitton as part of its *Travel*

Books series. During this trip Arsham considers how ruins and artifacts of the past compound time and shape one's understanding of the present, paving the way for his ongoing *Fictional Archaeology* series.

2011

Merce Cunningham Dance Company's last performances are staged at the Park Avenue Armory in New York. Arsham creates a set of pixilated clouds as part of the stage design.

The practice of stage design continues in collaboration with Jonah Bokaer with *Why Patterns* and *RECESS*, as part of Jacob's Pillow Dance Festival in Becket, Massachusetts.

Arsham creates *Dig* at the academic institution Storefront for Art and Architecture in New York, combining sculpture, performance, and architecture, which will become characteristic of Arsham's work.

The Walker Art Museum acquires the entire collection of sets, props, and costumes from the Merce Cunningham Dance.

2012

Arsham is married to Stephanie Jeanroy.

Snarkitecture begins an ongoing design collaboration creating the retail spaces for the streetwear brand KITH.

Centre Pompidou in Paris acquires the 2005 gouache on mylar work *Froggy* for its permanent collection.

Arsham Editions launches its first edition release in the form of a cast mobile phone entitled *Future Relic 01*. The editions company aims to create more accessible artworks available to a larger and younger audience of collectors.

Reach Ruin, a solo exhibition of Arsham's work, is presented at the legendary Fabric Workshop Museum in Philadelphia, Pennsylvania, and accompanied by a performance of *Study for Occupant*, a collaboration with Bokaer.

2013

Arsham's first son, Casper, is born.

Arsham's first film endeavor, *Future Relic 01*, is released. The film, released in chapters, follows the story of a young woman in a post-apocalyptic world searching for her father, who has disappeared after having excavated the moon in an attempt to save humanity.

2014

Future Relic 02, chapter two in the film series and accompanying editioned artwork, are both released.

Pixel Cloud is exhibited in the US Embassy in London as part of the Art in Embassies Program.

The result of a multiyear artwork production is presented at Locust Projects in Miami. The exhibition, *Welcome to*

the Future, dramatically excavated the floor of the gallery, exposing thousands of eroded cast pop culture objects below.

2015

An interactive music video to accompany the song "Chains" by Usher is directed by Arsham. It focuses on racial justice and police brutality.

The films *Future Relic 01–03*, starring Juliette Lewis, Mahershala Ali, and James Franco, are presented as part of the Tribeca International Film Festival.

Arsham is introduced to art collector and publisher Larry Warsh.

2016

Arsham's second son, Phoenix, is born.

A collaborative stage performance, the first of its kind, is commissioned by the historic Brooklyn Academy of Music. *Rules of the Game* combined an orchestral score written by Pharrell Williams and performed by the Dallas Symphony Orchestra, film and sculptural stage elements by Arsham, choreography by Jonah Bokaer, and costumes by Chris Stamp.

As a surprise to many, Arsham debuts his first ever solo exhibition in New York at Gallery Perrotin after more

than a decade living in the city. The show, *Circa 2345*, featured for the first time works in bright immersive colors such as blue and purple as a result of Arsham receiving colorblindness-correcting glasses.

Arsham's first exhibition in Japan, *My First Show in Japan, Year 2044*, opens at Nanzuka Gallery in Tokyo.

2017

At the High Museum in Atlanta, Arsham presents the solo exhibition *Hourglass*, inspired by ten years of travels with his wife in Japan and the gardens of Kyoto. The exhibition features a full-scale reproduction of a Japanese Tea House and Zen garden and is accompanied by audio narrative and performances.

Arsham exhibits his first monumental outdoor installation, *Blue Lunar Garden*, in Rio de Janeiro, Brazil, featuring an 8-meter torii gate framing Sugarloaf Mountain.

Arsham announces the Daniel Arsham Fellowship for YoungArts Award and mentorship program.

The first in a set of three sneaker designs is released in collaboration with Adidas.

2018

3018 opens at Galerie Emmanuel Perrotin New York as one of the highest attended exhibitions in the gallery's history.

Eroded DeLorean and *Eroded Ferrari* are included in the show and begin the artist's ongoing Eroded Vehicle Series.

As part of the expansion of KITH NYC, designed by Snarkitecture, the store features a one-quarter-scale art gallery co-owned by Arsham and Ronnie Fieg called Arsham/Fieg Gallery.

The Rhode Island School of Design Museum acquires the 2005 gouache on mylar work *The Return* 13.

Arsham purchases a historic 1969 home designed by famed American architect Norman Jaffe. The home is redesigned and renovated by Snarkitecture.

2019

Kim Jones, Artistic Director of Dior Homme, taps Arsham to collaborate in the design of the Dior S/S 2020 Men's Collection and show in Paris, using Arsham's signature eroded style as the basis for the design of garments and accessories.

Arsham's first large-scale museum exhibition in China opens at the HOW Museum. It includes a performed and interactive archaeological site and lab.

The Georgia Museum of Art acquires the 2007 architectural work *Columns*.

Arsham creates a pop-up retail experience at Selfridges in London for the store's holiday 2019 presentation,

including a selection of Arsham Studio branded and collaborative merchandise. In a nod to his early career Arsham calls the project "The House."

Working with the design and engineering teams of Porsche AG, Arsham creates the first drivable eroded car sculpture. The work debuted at the Selfridges in London and begins an ongoing worldwide tour and partnership with Porsche AG.

Legendary rapper Nas invites Arsham to design the cover artworks for his album *The Lost Tapes II*.

Arsham designs a collection of furniture for Friedman Benda as part of a special project for Design Miami, leading to the establishment of the furniture and design company Objects for Living.

2020

Arsham launches China-based editions company Archive Editions, allowing the artist to bring his own work and that of other creatives to the market of mainland China.

At the invitation of the Pokémon Company in Tokyo, Arsham reimagines the world of Pokémon through the eyes of the artist. It's the first collaboration of its kind in the company's history and results in a collection of clothing with the Japanese brand Uniqlo.

A four-meter bronze sculpture titled *Eroded Venus de Milo* is
 installed on long-term loan at UCCA Dune in Beidaihe,
 Hebei, as a preview for Arsham's upcoming solo show
 in 2021.

Arsham creates a site-specific installation entitled *Sports
 Ball Spiral* for the Qatar Olympic and Sports Museum.

Musée Guimet in Paris invites Arsham to create an exhibition
 based on works from the museum's permanent collection
 of Asian art and artifacts.

Four site-specific works are created in relationship to paint-
 ings from the permanent collection of the National
 Gallery of Victoria in Melbourne, Australia, for inclusion
 in the museum's 2020 Triennial and acquired into the
 permanent collection of the museum.

Arsham is appointed Creative Director of the Cleveland
 Cavaliers basketball team. The appointment is the first
 of its kind for any visual artist.

ILLUSTRATIONS

Frontispiece: Portrait of Daniel Arsham, 2018. © James Law.

Page 120: Daniel Arsham, Study for the *Eroded Lucius Verus*,
 2019. Courtesy of the artist.

ACKNOWLEDGMENTS

First and foremost, my thanks go to Daniel Arsham, whose thoughts and words comprise the basis of this publication. It is an honor to be aligned with such an incredible thinker and creative mind.

My sincere thanks to Meghan Clohessy, Tori Geddes, Haley Martell, Eunice Chun, Austin Snyder, and the entire Arsham Studio for their professionalism and valued assistance on our many endeavors.

My deepest thanks as well to Karl Cyprien for his thoughtful insights throughout the formation of this book, and to Haisong Li for her continued support on this and many other projects.

My heartfelt appreciation to the entire team at Princeton University Press, especially Michelle Komie, Christie Henry, Terri O'Prey, Cathy Slovensky, and Kenneth Guay. We remain extremely grateful to PUP for their continued professionalism, encouragement, and passion for our projects together throughout the years.

My very special thanks to Fiona Graham for her invaluable research and organization of this publication.

My thanks as well to Vanessa Lee, Kevin Wong, Keith Estiler, Noah Wunsch, Man Hoang, Sarah Sperling, and Jahan Loh for their global support. Thanks also to Mike Dean, Louise Donegan, Carlos "oggizery_los" Desrosiers, Derek Ali, A$AP Ferg, Mitchell Julis, Ben Milstein, Dan Noble, and John Cahill.

My sincere thanks to Taliesin Thomas for her amazing assistance on this and many other projects, to Aemilia Techentin for her supporting research, and to Zara Hoffman, Steven Rodríguez, and John Pelosi for their continued support.

Finally, I give all my bottomless gratitude to my amazing wife, Abbey, and to my wonderful children, Justin, Ethan, Ellie, and Jonah for their love and encouragement.

As always, I give endless love and thanks to my mother, Judith.

LARRY WARSH

New York based artist **Daniel Arsham's** work explores the fields of art, architecture, performance, design, and film. Born in Cleveland and raised in Miami, Arsham attended the Cooper Union in New York City, where he received the Gelman Trust Fellowship Award in 2003.

Early in his career Arsham toured worldwide with the Merce Cunningham Dance Company as the company's stage designer. The experience led to an ongoing collaborative and multidisciplinary practice. Arsham co-founded an architecture and design company in 2007 called Snarkitecture. His collaborative nature has infiltrated the mainstream through collaborations with brands such as Dior, Rimowa, and Adidas, and musicians such as Pharrell, Usher, and Nas. In 2019 Arsham debuted his first collection of furniture called Objects for Living with Friedman Benda at Design Miami.

Arsham's aesthetic revolves around the concept of fictional archaeology. Working in a variety of media he creates and crystallizes ambiguous in-between spaces or situations, and stages what he refers to as future relics of the present. Always iconic, the objects that he turns into stone refer to the late twentieth century or millennial

era, when technological obsolescence unprecedentedly accelerated along with the digital dematerialization of our world. While the present, the future, and the past poetically collide in his haunted yet playful visions between romanticism and pop art, Arsham experiments with the timelessness of certain symbols and gestures across cultures.

Arsham's work has been shown at The Museum of Contemporary Art in Miami, The Athens Biennale in Athens, Greece; The New Museum in New York; the HOW Museum in Shanghai; Cranbrook Art Museum, Detroit; the Mosaic Art Foundation in Istanbul; and Carré d'Art de Nîmes.

Arsham is represented by Galerie Perrotin in Paris, Hong Kong, New York, Seoul, Shanghai, and Tokyo; Ron Mandos in Amsterdam; Nanzuka Gallery in Tokyo; and Baro Gallery in São Paulo and Madrid.

Larry Warsh has been active in the art world for more than thirty years as a publisher and artist-collaborator. An early collector of Keith Haring and Jean-Michel Basquiat, Warsh was a lead organizer for the exhibition *Basquiat: The Unknown Notebooks*, which debuted at the Brooklyn Museum, New York, in 2015, and later traveled to several American museums. He has loaned artworks by Haring and Basquiat from his collection to numerous exhibitions worldwide, and he served as a curatorial consultant on *Keith Haring | Jean-Michel Basquiat: Crossing Lines* for the National Gallery of Victoria. The founder of *Museums Magazine*, Warsh has been involved in many publishing projects, including *Keith Haring: 31 Subway Drawings*, and is the editor of several other titles published by Princeton University Press, including *Jean-Michel Basquiat: The Notebooks* (2017), *Basquiat-isms* (2019), *Haring-isms* (2020), *Futura-isms* (2021), *Abloh-isms* (2021), and two books by Ai Weiwei, *Humanity* (2018) and *Weiwei-isms* (2012). Warsh has served on the board of the Getty Museum Photographs Council and was a founding member of the Basquiat Authentication Committee until its dissolution in 2012.

ISMs

Larry Warsh, Series Editor

The ISMs series distills the voices of an exciting range of visual artists and designers into captivating, beautifully made books of quotations for a new generation of readers. In turn passionate, inspiring, humorous, witty, and challenging, these collections offer powerful statements on topics ranging from contemporary culture, politics, and race, to creativity, humanity, and the role of art in the world. Books in this series are edited by Larry Warsh and published by Princeton University Press in association with No More Rulers.

Arsham-isms, Daniel Arsham
Abloh-isms, Virgil Abloh
Futura-isms, Futura
Haring-isms, Keith Haring
Basquiat-isms, Jean-Michel Basquiat
Weiwei-isms, Ai Weiwei